TATTOOS

The Henk ("Hanky Panky") Schiffmacher Collection

TASCHEN
amuse-gueule

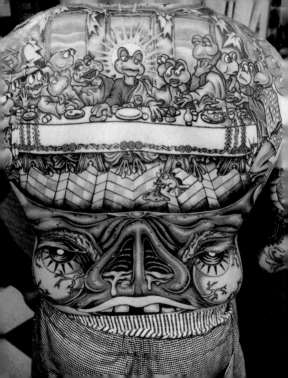

The art of tattooing is an ancient craft known to mankind for thousands of years. In its earliest form it was used by primitive peoples as camouflage for the hunt, but soon took on more complex functions within increasingly structured forms of society. Whatever its purpose, tattooing has always been unique to each wearer and has always reflected the individual's personal needs. The practice of tattooing frightening images on the skin as a means of protection is particularly widespread, and has been adopted by archaic cultures and modern bikers alike to deter enemies by intimidation. Tattoos also have a long tradition of signalling membership of a specific cultural group, ethnic tribe or inner city gang. At the turn of the century, when they were worn only by the travelling people who were despised as the lowest of the low, tattoos

were regarded as the brandmark of criminals or social outcasts. That image has since changed fundamentally. Tattoos today are widely acknowledged as a form of body ornament that expresses a personal message. Contemporary tattoos are as stylistically diverse as fashion itself, and the art of tattooing today has reached an aesthetic and technical zenith that is reflected in countless schools and crossovers. All 56 photos in this book show motifs from the collection of the Amsterdam Tattoo Museum. The only one of its kind in the world, the museum was founded in 1996 by Henk Schiffmacher, alias "Hanky Panky".

Tätowierungen kennen wir bereits aus der Frühgeschichte der Menschheit. Traten die ersten Formen bei Naturvölkern noch als Jagdtarnung auf, so wurde ihre Funktion in strukturierten Gesellschaftsformen bald komplexer. Was auch immer die Aufgabe der Tätowierung war und ist – sie ist speziell auf die Person ihres Trägers zugeschnitten und vermittelt dessen ganz persönliche Bedürfnisse. Vielfach verbreitet ist die Schutzfunktion durch abschreckende Bilder, wie man sie in archaischen Kulturen ebenso wie bei Bikern vorfindet. Ziel ist es, den Gegner einzuschüchtern, ihn mit Bildern in die Flucht zu schlagen. Des weiteren war und ist die Tätowierung als Abgrenzung bzw. Zugehörigkeitsbezeugung bestimmter Gruppen besonders verbreitet. Diese Funktion erfüllen die Stammestätowierungen

genauso wie die Gang-Tattoos amerikanischer Jugendbanden. Waren Tätowierte zu Beginn unseres Jahrhunderts noch als Verbrecher verpönt – tätowiert war nur das fahrende Volk, die gesellschaftlich Geächteten also –, so hat sich dieses Bild in unseren Tagen gewandelt. Die Tätowierung ist ein allgemein anerkannter Körperschmuck, die ihren Träger nach außen hin definiert. Die Formen zeitgenössischer Tätowierungen sind so vielfältig wie die der Mode, und die Tätowierkunst unserer Tage befindet sich sowohl ästhetisch als auch technisch auf einem absoluten Höhepunkt, der sich in unzähligen Schulen und Crossovers äußert. Alle 56 Photos zeigen Motive aus den Beständen des Amsterdam Tattoo Museums. Das Museum ist weltweit einzigartig und wurde 1996 von Henk Schiffmacher alias „Hanky Panky" gegründet.

Les tatouages existent depuis l'aube de l'humanité. Simples camouflages de chasse chez les peuples primitifs, ils revêtent des fonctions beaucoup plus complexes dans les sociétés structurées. Néanmoins, quelle que soit sa fonction, le tatouage est toujours réalisé pour une personne particulière et répond à des besoins personnels. Il est fréquemment utilisé pour protéger celui qui le porte. On trouve ainsi de très nombreux motifs destinés à faire peur, tant dans les cultures archaïques que chez les motards. Leur but est d'effrayer l'adversaire pour qu'il prenne la fuite. L'autre grande fonction du tatouage est d'indiquer l'appartenance à un groupe. C'est le cas des tatouages propres à certaines tribus, mais aussi des signes distinctifs des bandes de jeunes Américains. Au début de ce siècle, les tatouages étaient encore réprouvés et

considérés comme l'apanage des criminels. Si la population tatouée était alors souvent marginale, aujourd'hui la situation a bien changé. Le tatouage est accepté comme un ornement corporel mis en avant par la personne qui le porte. Les tatouages contemporains sont aussi variés que les modes, et témoignent d'une exceptionnelle maîtrise, tant au niveau technique qu'esthétique. Ces 56 photos proviennent du fonds de l'Amsterdam Tattoo Museum. Ce musée unique au monde a été fondé en 1996 par Henk Schiffmacher, alias « Hanky Panky ».

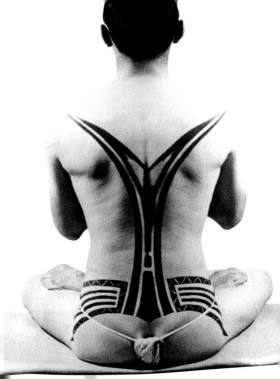

21-3-20-4.

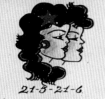

21-5-21-6.

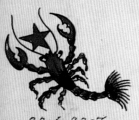

22-6-22-7.

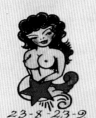

23-8-23-9.

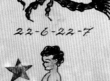

21-1-19-2.

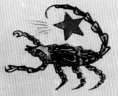

23-10-21-11.

00-1962.

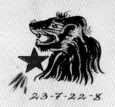

23-7-22-8.

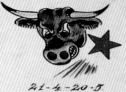

21-4-20-5.

24-9-23-10.

22-11-22-12

23-12-20

20-2-20-3.

COPR. BY TATOVØR-OLE.
NYHAVN 17. COPENHAGEN.

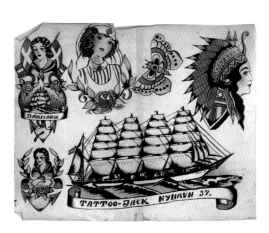

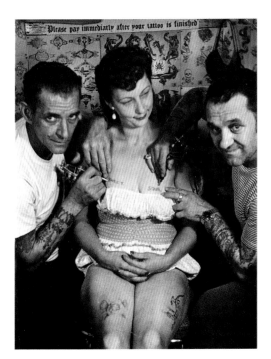

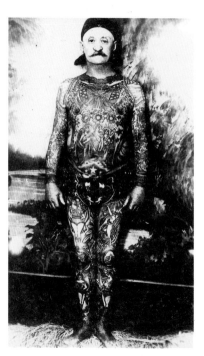

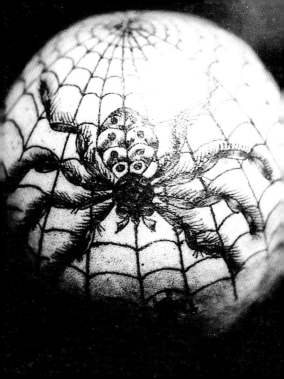

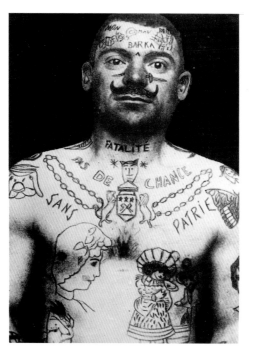

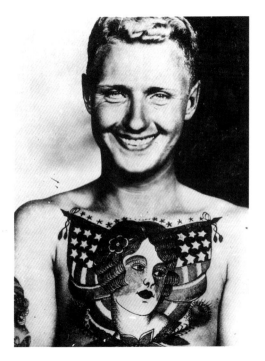

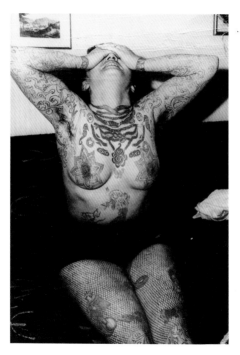

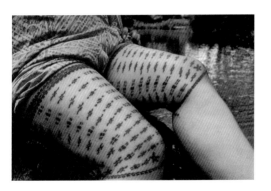

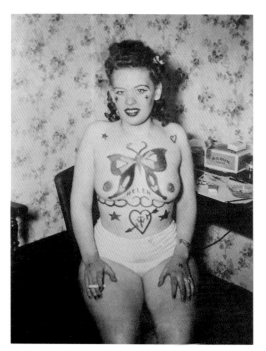

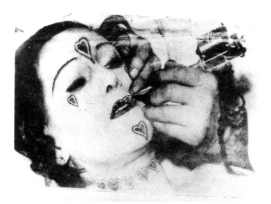

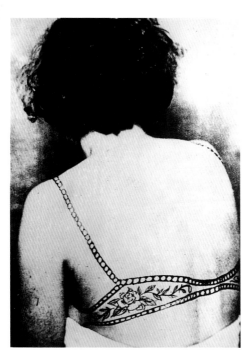

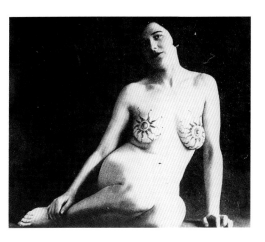

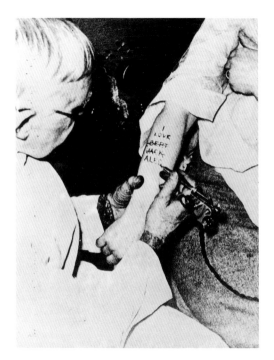

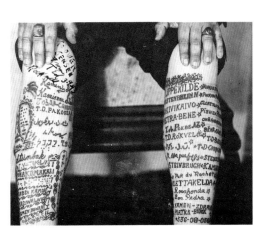

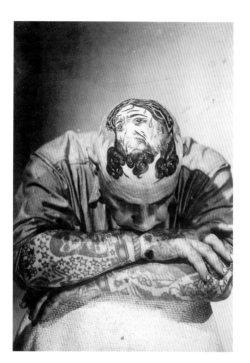

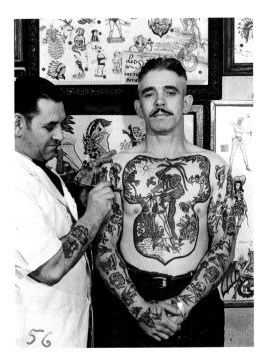

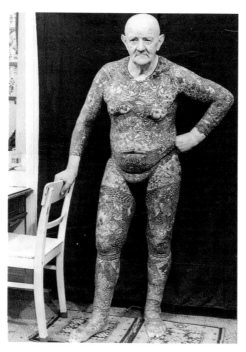

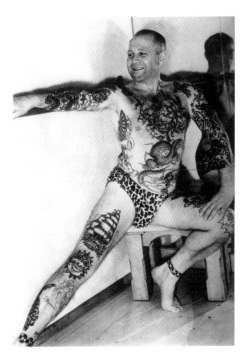

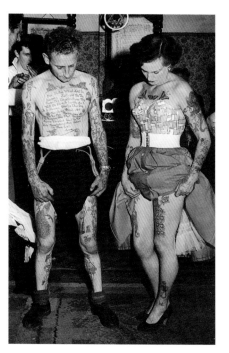

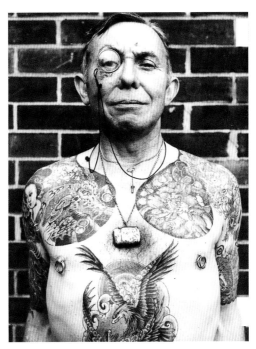

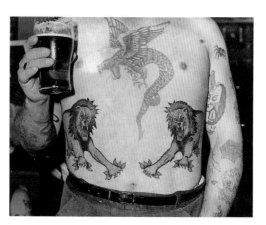

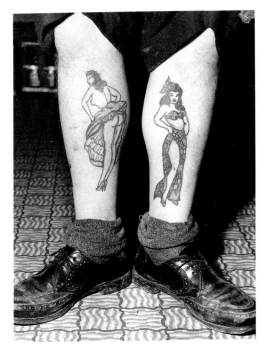

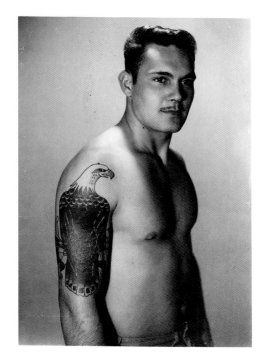

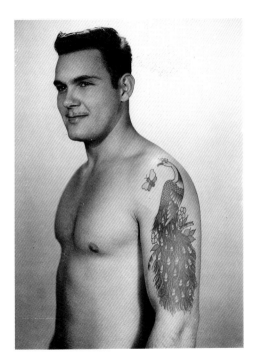

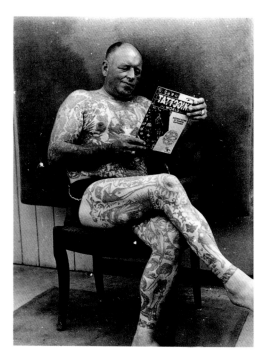

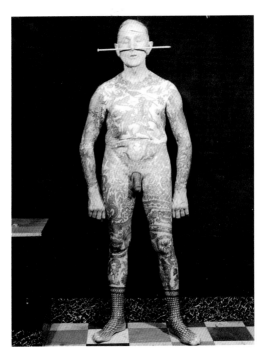

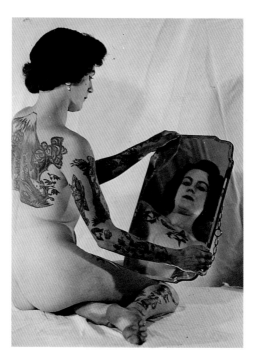

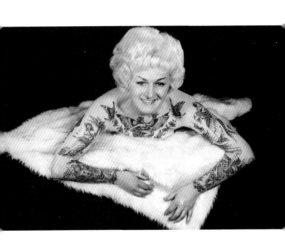

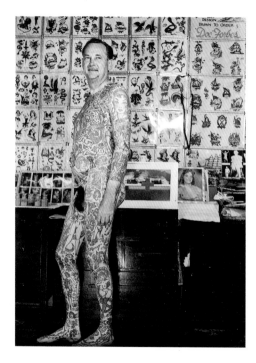

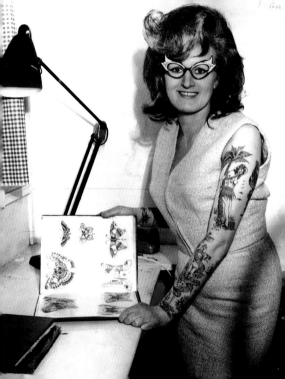

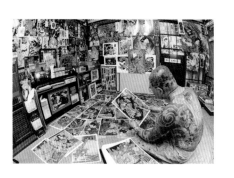

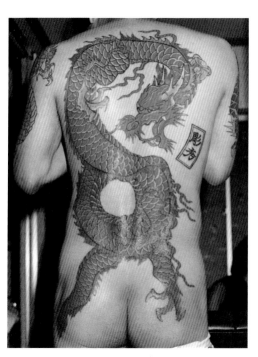

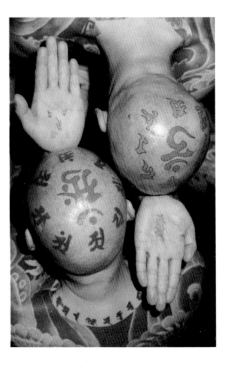

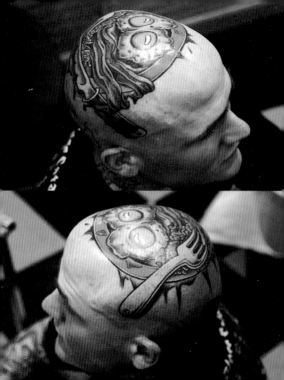

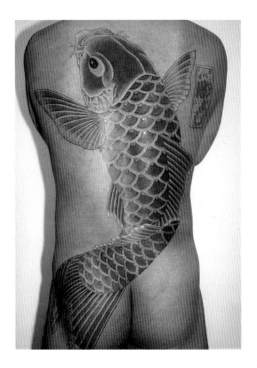

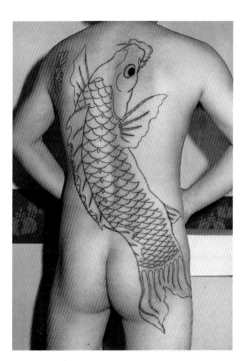

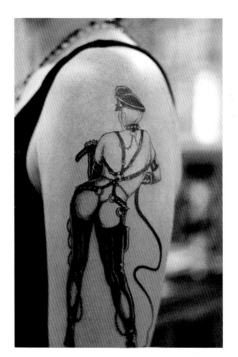

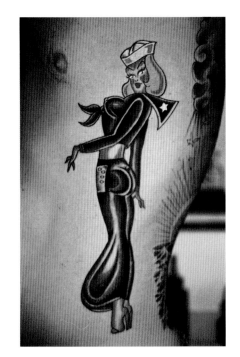

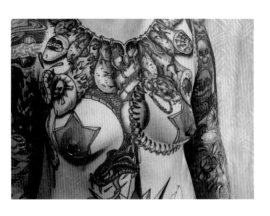

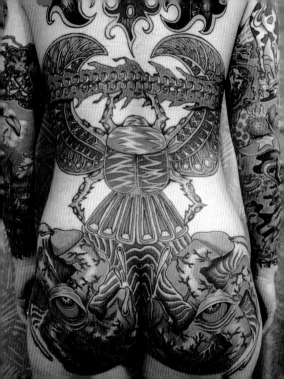

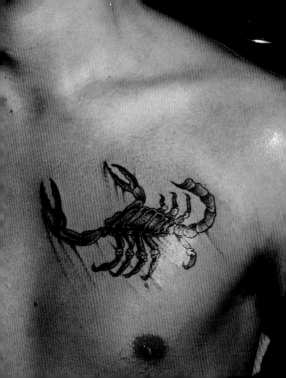

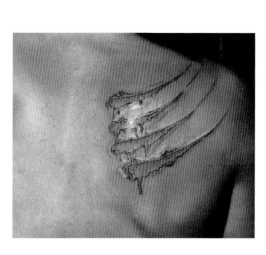

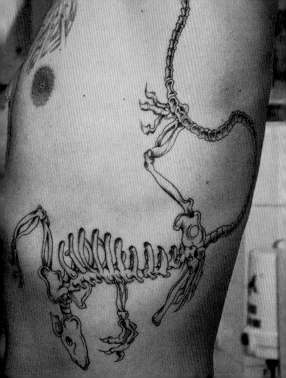

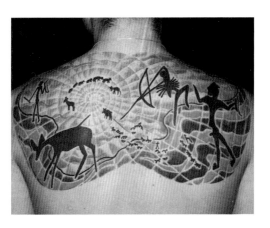

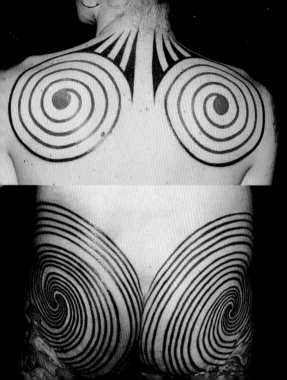

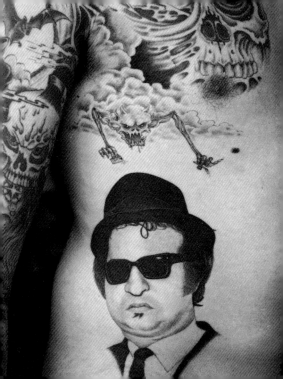

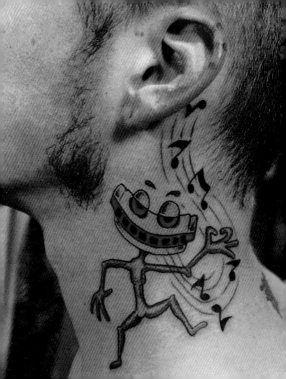

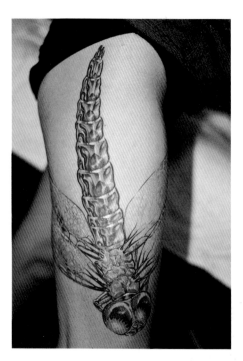

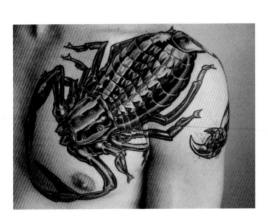

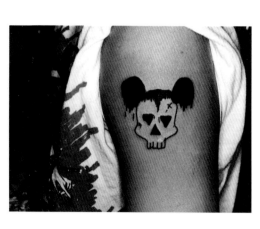

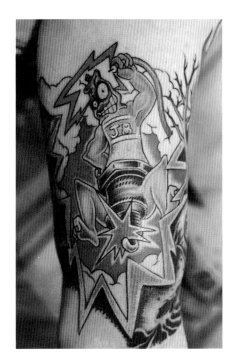

1000 Tattoos

Henk Schiffmacher
704 pages, 668 illustrations
US$ 29.99, £ 16.99, DM 39,95, FF 157,50

This book was printed on 100 % chlorine-free bleached paper
in accordance with the TCF standard.

© 1996 Benedikt Taschen Verlag GmbH
Hohenzollernring 53, D–50672 Köln
© 1996 for the illustrations:
The Amsterdam Tattoo Museum, Amsterdam
Text: Burkhard Riemschneider, Cologne
Printed in Germany
ISBN 3-8228-8163-5